Zuni Pottery

Zuni Pottery

Marian Rodee and James Ostler

West Chester, Pennsylvania 19380

Printed in the United States of America.
ISBN: 0-88740-100-7
Published by Schiffer Publishing Ltd.
1469 Morstein Road, West Chester, Pennsylvania 19380

This book may be purchased from the publisher.
Please include $1.50 postage.
Try your bookstore first.

Catalogue of an Exhibition *From the Center Place: Contemporary Zuni Pottery and Its Makers* at the Maxwell Museum of Anthropology, University of New Mexico. March 14, 1987 to September 1, 1987.

Long ago the Zuni people emerged from the underworld at a place either in the Grand Canyon or Mojave Desert into this world. They wandered for generations until they arrived at their present homeland which they feel is the center or middle of the world, equidistant from the four oceans which surround the known world.

Foreword

My introduction to Zuni pottery began in 1984 when the Pueblo of Zuni started their own arts and crafts enterprise to purchase and market Zuni arts. I was invited by the Governor and council to live at the Pueblo and to organize and manage that enterprise. As there are upwards of one thousand craftsmen working in the Pueblo this project was seen almost entirely in economic terms, i.e. the means by which employment could be increased and at the same time fit into the cultural norms of the Pueblo. This was not analogous to a computer chip factory opening at the Pueblo, rather, it was the tribal reinforcement of the cottage, craft industry which has been active at the Pueblo for the past fifty years. All crafts at Zuni are done in the home—on the kitchen table, in a trailer parked beside the house, or in a back room. Children learn from their parents or an elder family member. Almost all families at Zuni earn most or part of their income from their art.

We have tried to create a tribal arts and crafts enterprise to stimulate all the arts—those that are well known, silversmithing and lapidary work, for example, as well as those which are little practiced or only known from historical surveys. When we first placed pottery on the shelves of the store, both individuals, and wholesale buyers would remark that they did not know the Zunis still made pottery. In fact, Zunis had never stopped making pottery, but it had been made more for use within the Pueblo than for the tourist/collector market. It was made as corn meal vessels for kiva groups or medicine societies or as stew bowls and water vessels for feast days. It was produced by family members to be given to other family members or to be traded to Zunis outside the family. Occasionally teachers or hospital personnel would be sold pottery, and sometimes a trading post or a dealer in Albuquerque would purchase pieces.

I suppose that one could say that the Pueblo of Zuni Arts and Crafts (the tribal enterprise) has been concerned more with the sustaining of crafts at Zuni than their preservation. "Preservation" implies keeping the craft going in the same form and with the same materials, whereas "sustaining" implies helping craftsmen

to maintain their skill and knowledge, so that they may be passed on to younger craftsmen. In the two and a half years that we have been buying and selling pottery at the Pueblo it is not so much a rebirth that we have seen but rather it has been an increase in the number of potters selling their work and an expansion of the shapes and designs that are used. When we started there were five potters from whom we consistently purchased, and now there are twelve. In every case but one this has been the result of incorporating additional family members in the making of pottery. From my observation there have been two tracks in the 1980's by which Zunis have become potters. One track has been the high school program where students have taken pottery making as an art class elective. The other track has been where family members have been taught by their mother or mother-in-law. Of the twelve potters from whom we consistently buy there are three in the first category and eight in the second. I would suggest that no small role in the increase of potters has been the arts and crafts enterprise consistently buying their work.

Zuni is an artistic community. Every member of the community grows up with the making of art, not in the sense of following the romantic vision of modern artists, but as the son or daughter of a silversmith, or in a few cases as a potter or as a member of a kiva group or medicine society. There is no community of which I have been part, and this includes professional art schools, where I have found a higher sense of craftsmanship, propriety and criticism in the arts. It is not that art is in the blood, rather it is in the workplace and in the religious place. Katchina dances occur throughout the year at Zuni, and again and again I will hear critical comments and praise of the dances. "That group wasn't any good. Did you see their costumes? Did you see how they barely moved." Or, "I want to go see the Longhairs dance and see all their turquoise." The criticism of form and performance is unending, even the Mudheads will be criticized for not doing things as they should. Craftsmen are always coming in the store and telling us what is good and what is not. There is always an opinion, never neutrality. "The work is clean." Look at this, it's like her (his) former husband (wife)." What good work that person does, I wish I were that creative." "That person is copying my designs." I have heard silversmiths say that when they were young they could not wait until their parents would go to Gallup for then they could go to their parents' work bench and make things from the scrap silver and stones.

I think that the contribution of the arts and crafts enterprise to the potters has been twofold: we have purchased their work and

we have taken steps to introduce potters to museum collections. In one case a fellowship was secured for one of the leading potters to take younger potters to the museum collections of the School of American Research and to teach them how to do traditional, sheep manure firing. In another case, we were instrumental in sending six potters to the Smithsonian-sponsored Folklife Festival wherein potters demonstrated their craft for two weeks and studied the Smithsonian collection of Zuni pottery. I had thought that the results of looking at historic pottery by the Zuni potters would be diffused and slow in taking effect; in fact, they were almost immediate. No less than a month after the museum visits I was seeing pots of different shapes and older designs clearly inspired by pots in the museum collections. Another change that took place was that pots got bigger and more elaborate—more sculptural, with raised effigy figures and additional colors being used. When I first started buying pottery, the designs that I saw were white slipped pots with black painted heartline deer designs or medallions, now I was seeing polychrome pots, unslipped pots, redware, and pots with closely hatched lines. The reaction of the buying public was immediate, not only from collectors who would visit the store, but also from dealers, and we started receiving orders for this new "old" Zuni pottery. Occasionally, collectors would say that this was not Zuni pottery, but from the Zunis we hear only comments of praise and questions of "Who did it?"

As far as I can see there have been three means by which pottery in the 1980s has been sustained at Zuni: (1) traditional use, (2) the advanced collector and (3) the general market place. Corn meal vessels are needed for religious occasions, and stew bowls required for feasts; such pots are generally traded by the potter to the Zuni who have need of them. Generally speaking the designs seem to have been traditional, early twentieth century motifs, the emphasis not being on innovation but on producing a functional pot of good Zuni design. However, after the "new" pots have been seen and admired at Zuni the potters start receiving Zuni requests for them as well. It has been the more knowledgeable collectors who have made a greater impact on re-introducing older Zuni designs; and either on their own or through a dealer have requested pots with specific images, sizes and motifs. Sometimes their request would be met with enthusiasm as an opportunity for the potter to do another kind of pot, but other times with a rather non-committal "I'll try", or the comment "That's not the way I do pottery." Now I find that it is the potters who are several steps ahead of the collectors both in their appreciation of what is old at

9

Zuni and what is innovative. The tribal enterprise will only buy pottery which is made with Zuni clay and traditional pigments. And we will pay more for pottery which is fired with sheep manure in the traditional manner. This is partly in recognition of the fact that the potter takes greater risks in firing outdoors and also to provide an economic incentive for the sustenance of this traditional craft. It is not uncommon to find potters reluctant to risk breakage in a traditional firing when they have invested a great amount of time in the shaping and painting of a piece. One potter, for example, will fire with sheep manure when her electric kiln is broken. The contrast is with two older potters—one who has become known for her thin walled traditionally fired pieces and who rejects kiln firings as "not the way Zuni pottery is made" (her children not necessarily agreeing) and the other who will sometimes fire in kilns when the weather is bad or sometimes not fire outdoors when there is illness in the family. What I am suggesting is that the outside economic forces and inside religious forces cut both directions in the sustaining of "traditional Zuni pottery." Slip cast (greenware) painted pottery was made by a family sponsoring the Mudhead House as a gift to the Mudheads, but Zuni clay was not used because there was not time to make the six large stew bowls. (Fig. 45) Traditional clay, painting, and firings will be used by some potters because that is the way they do it, which they also recognize is how their buyers know their work. Potters may not fire on inclement days simply because they do not want to risk broken pottery which they cannot sell, nor do they want to risk the threat to their family which tradition dictates comes from broken pottery. Some feel that broken pots will cause a death in the family, if someone is already ill. I am continually impressed with the ease by which the people of Zuni combine pragmatism and traditional beliefs; quite apart from the beauty of their pottery this is something else that we might learn from the Zunis.

James Ostler
Manager, Pueblo of Zuni Arts
and Crafts

Contents

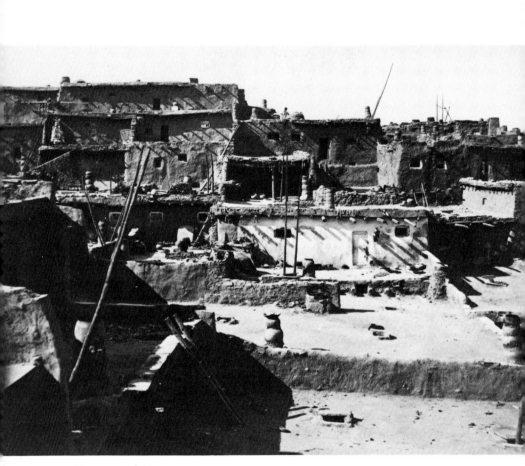

Figure 1. Village of Zuni looking Northeast. 1879. Photo by John K. Hillers. Courtesy of the Museum of New Mexico. Negative no. 22818.

Introduction

The village of Zuni lies one hundred and fifty miles west of the Rio Grande Valley on the border of Arizona and New Mexico. (Fig. 1) Although its language is unique to Zuni, with no known relatives on the North American continent (Woodbury 1979, 468), its culture is similar to that of other Pueblo groups. All modern Pueblo societies are rooted in the prehistoric Anasazi culture of northern New Mexico and Arizona. There are numerous sites dating from 700 a.d. to the present in the Zuni area.

Zuni was discovered by the Spanish in about 1539 as the result of stories told by two men, Cabeza de Vaca and the black Esteban, both survivors of a shipwreck off the Florida coast in 1528. (Woodbury 1979, 469-471) For ten years the two men wandered throughout what is now the southern and southwestern United States. When they finally reached the Spanish capital in Mexico City they told wondrous tales of the fabulously rich Seven Cities of Cibola to the north. A small party led by Father Marcos de Niza and Esteban visited Zuni in 1539. Esteban went ahead into the village and was killed by the men, supposedly because of his arrogant behavior. Father de Niza observed Zuni from a distance and went home with reports that only fueled the fires of greed in Mexico City. A large well-armed expedition led by Francisco Coronado visited Zuni in 1540. The Zuni warriors fought Coronado and his men, their first and only battle with Europeans. Although a mission was established and soldiers were garrisoned there, no Spanish civilians lived in the Zuni area until the late nineteenth century. The Zuni aligned with the other Native American subjects of the Spanish in ejecting their masters in the Pueblo Rebellion of 1680. At this time the Zuni were living in six villages, but they then abandoned them and lived in small settlements on the top of Corn Mountain rather than in the valley of the Zuni River. After the reconquest of 1692, the Zuni resettled in the valley again but in one village. There is still one large village where all the important ceremonies are held, but once again the community has formed smaller units, primarily for farming and sheep ranching. Because the Spanish presence was not as close and enveloping as it was along the Rio Grande, the

Zuni have retained more of their traditional culture and religion than the Indians of many other communities. Important changes were introduced by the Spanish, some beneficial such as sheep, burros, horses, and wheat as well as a wide range of new diseases, which caused a drastic reduction in the population of Zuni.

Traditionally the political leadership was exercised by the religious leaders, now however as a result of dealing with the Spanish and then American administrations there are two sets of leaders, the traditional religious ones and the democratically elected tribal officials. Families still reckon kinship in the female line and the husband goes to live with his wife and mother-in-law in the traditional way. The close knit kin groups and the elaborate religious ceremonies holds the Zuni community together (Ladd 1979, 482).

✿✿✿✿✿✿✿✿✿✿✿

Pottery:
Function and Meaning

Pottery is essentially a useful art form and although today most pottery is made for the collectors' market many pots still serve their original purposes within the Zuni community. (Fig. 2) Open bowl shapes in large sizes are used for mixing bread dough and as communal stew bowls while many older examples show wear and fatty deposits indicative of long, hard use (Fig. 3). Now such old bowls are treasured as family heirlooms and used for baptismal bowls (Hardin 1983, 5 and fig. 4) While large jars are no longer used to store a household's food and water, they are kept to store the family's religious objects. The small corn meal bowls with and without handles are produced in great numbers (Figs. 32, 61) and used in most families for their original purpose to hold the sacred corn meal so necessary for traditional prayers, the Zuni equivalent of holy water.

The major traditional forms produced today are small bowls, jars of all sizes (mostly small to medium) and corn meal bowls. Other traditional forms such as canteens (Figs. 5, 15) have been revived as a result of museum visits and looking at book illustrations but they are no longer used by hunters to carry water on trips.

There have been several major studies of the symbolism of Zuni pottery design (Cushing, Stevenson, Bunzel), as well as a recent survey of the collections and unpublished manuscripts of Stevenson and Cushing at the Smithsonian (Hardin). Although the subject of symbolism is questionable in most areas of Native American arts there is universal agreement among the Zuni informants from Cushing and Stevenson's time in the 1880s and 1890s through Bunzel in the 1920s down to the present, that all geometric designs are meaningful. As might be expected in an arid land where agriculture in the past was only possible by controlling rainwater runoff and directing it into fields, water and the animals associated with the seasonal rainfall are the predominant symbols on pottery. Tadpoles, dragonflies and frogs symbolic of early, mid, and late summer rains and the seasonal ponds formed by them are commonly found on pottery (Figs. 6, 7, 11, 51) The stepped rim on cornmeal bowls is

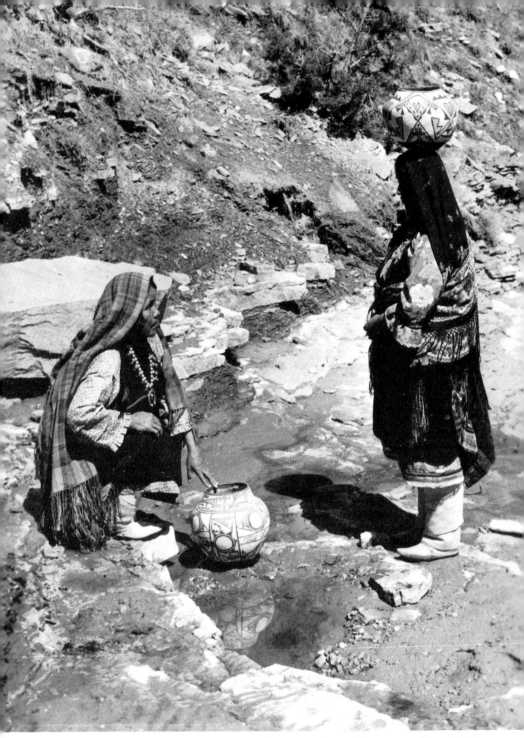

*Figure 2. Zuni women at a spring. Frashers Photograph, c. 1925.
Maxwell Museum of Anthropology.*

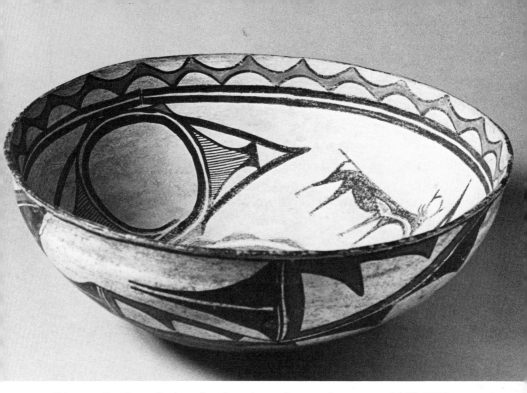

Figure 3. Dough bowl, showing signs of use, c. 1900-1920. Maxwell Museum of Anthropology. Photo by Michael Mouchette.

representative of the rainclouds. Hatching, that is the drawing of fine parallel lines, is not only a decorative technique giving rich texture to the painted surface of jars, but also a symbolic illustration of the falling rain. This representation of the rain falling from a summer storm was called the "rainbird" originally by H.P. Mera of the Museum of New Mexico (Mera 1933) (Fig. 4). The meaning of the rainbird is described by a Zuni potter on p. 57. Stylized feathers are frequently incorporated into geometric designs (Fig. 3).

Bunzel records a potter telling her that since women were not permitted to make prayer sticks, the women painted them on their pots as a form of prayer (Bunzel 1929, 106). Frequently the entire prayer stick is painted on the pot. (The large circular design in the center of Figure 3.) Prayer sticks are small pieces of wood with bird feathers and cotton attached and placed on altars and shrines as offerings, much like lighting a candle in a Catholic church. Pottery in the past thus served both a utilitarian role and was a religious act by the potters who made them. The design most often associated with Zuni is that called "the deer in his house". The deer has a "heartline" running from his mouth to

his heart representing the life or spirit of the animal. (Fig. 16) The line is always red and surrounded by a white space. Sometimes the animals are shown paired, male and female and occasionally spotted fawns are also represented. One of Bunzel's potters said she painted the deer so her husband would have success while hunting. (Bunzel 1929, 94)

Today, as in the past, effigy figures are made by the potters. These little animal figures may be a parallel in clay of the stone fetish carving done by men. Some (Fig. 18) are done in the same style as the stone fetishes, including the animals' heartline. Others as in Fig. 19 are more realistic representations of important animals. The bear is probably the most popular subject for fetish carvers today and is second in popularity with potters. The most common animal figure in clay is the owl. Many owls were collected by the Smithsonian in the late 19th century, but it is not clear why they were made, perhaps an early collector's item. However, the representatives of the Smithsonian were interested in other matters and did not ask about the owls. Both the bear and owl are respected hunters, the bear in day and the owl at night and this may have something to do with the popularity of these two animals in Zuni art. Some owls today have owlets perched on their wings and shoulders. They are often called "storyteller" owls in reference to the figures from the Rio Grande Pueblos of a man or woman telling stories with small children climbing all over them.

<p style="text-align:center">❧❧❧❧❧❧❧❧❧❧❧</p>

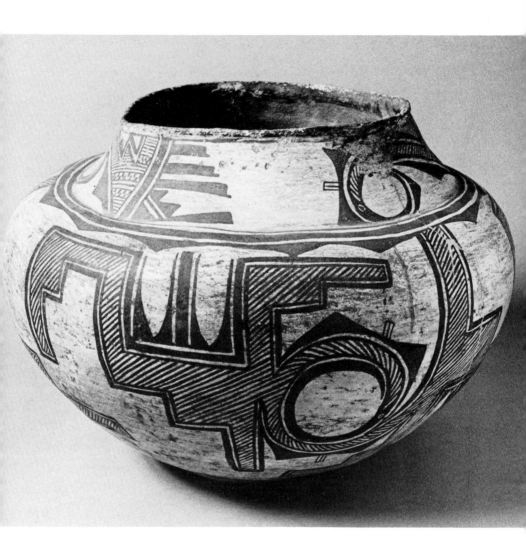

*Figure 4. Water jar with rainbird design. c. 1880-1900. Maxwell
Museum of Anthropology. Photo by Michael Mouchette.*

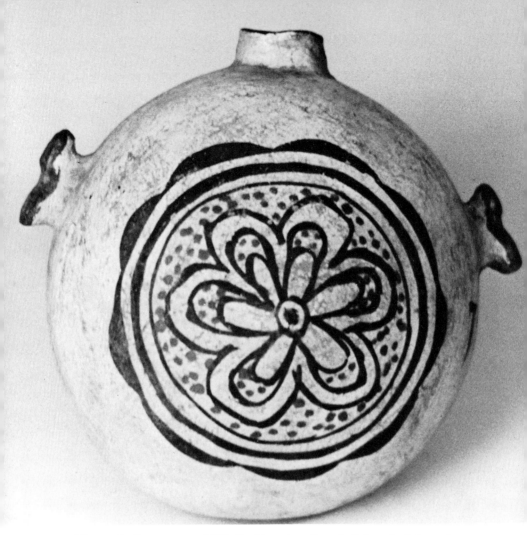

Figure 5. Canteen, c. 1900. Indian Arts Fund, School of American Research.

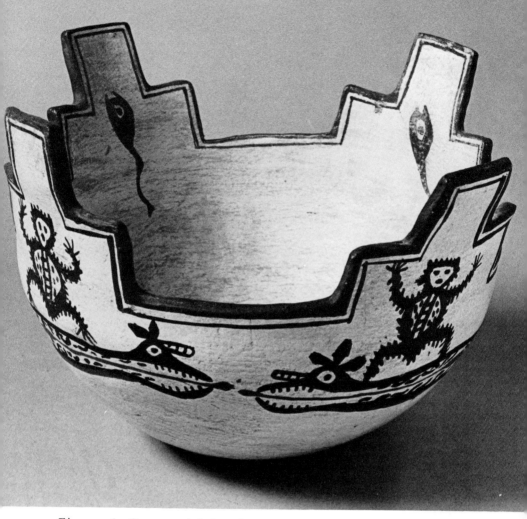

Figure 6. Ceremonial bowl. c. 1900. Maxwell Museum of Anthropology. Photo by Michael Mouchette.

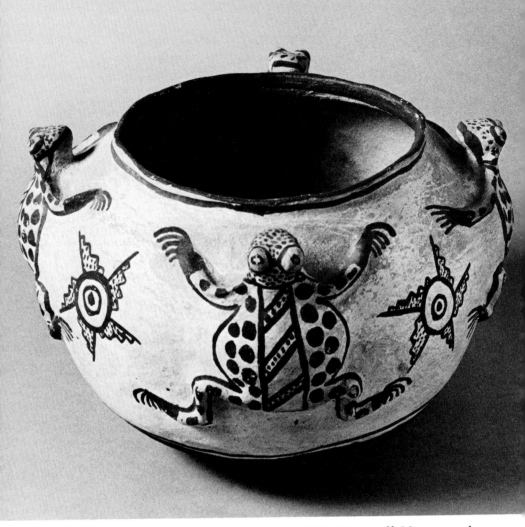

Figure 7. Jar with frogs in relief. c. 1900. Maxwell Museum of Anthropology. Photo by Michael Mouchette.

The Potters Today

The Zuni have never ceased making pottery and, although there have been periodic "revivals" during the twentieth century, such revivals usually just meant an increase in the quantity produced and more attention given to pottery by the outside world. One such period of outside interest and stimulation is taking place now. In 1985 the School of American Research in Santa Fe, N.M. gave the Katrin H. Lamon Fellowship to potter Josephine Nahohai so that she might teach other Zuni women. She and other potters such as the Kalestewa family visited the collections of the School as well as those of the Laboratory of Anthropology and the Maxwell Museum where they made sketches of early examples of Zuni pottery. In the summer of 1986 some of these potters went to the Smithsonian to demonstrate their art at the summer folklife festival on the Mall in front of the Museum. They shared the space with a group of Japanese potters. This was a stimulating experience especially for the young potters Randy and Rowena Nahohai who exchanged pieces with the Japanese. Randy has some clay given to him by one of the Japanese and he plans to work with it some day. None of the pots that the Zuni fired in Washington turned out, they all broke in the kiln, but Randy painted a jar thrown on the wheel by the Japanese potter and he and other Zuni potters tried out the wheel. Just as valuable for them was seeing the remarkable collection of Zuni pottery at the Smithsonian. Collected in the last quarter of the nineteenth century by Matilda Coxe Stevenson and Frank H. Cushing these pieces comprise the largest and finest collection of Zuni pottery in the country.

The result of these visits has been a renewed burst of creativity in the art of pottery making at Zuni. Although pottery has never died at Zuni, it has never enjoyed the popular recognition outside the village that has been accorded the production of the other New Mexico Pueblos. The greatest natural resource of Zuni is the artistic creativity of its people. The Reservation does not have the vast mineral deposits of the Navajo lands and while there is sufficient water to irrigate and support livestock and crops, the main economic activity at Zuni is arts and crafts (Ladd 1979, 482).

One notices numerous craft businesses as soon as one enters the village. The preeminent art form is that of jewelry, especially that requiring fine lapidary work. Jewelry making is heavily dependent upon external factors, such as the price of silver, cheap foreign imports done in imitation of the Zuni style and most important, the taste and fashion trends in American society as a whole. At the present time, the price of silver is still fairly high and there is a slump in the jewelry market, therefore artists are working in other media. Families turn easily from jewelry to pottery to beadwork depending on economic and physical conditions. If it is too damp, or windy to fire pots, artists turn to beading.

The Kalestewas are one such family that has turned from jewelry to pottery. The family jewelry workroom is clean and quiet with all the tools in storage. Quanita Kalestewa (Fig. 8) said the price of silver was high now and that breathing dust from grinding some of the shells was dangerous, so the family is concentrating on pottery. Pottery making was done in a camper/trailer behind the house in order to keep the fragile pottery away from the family's small children.

Quanita's mother is Nellie Bica, who is probably the most famous of the Zuni potters. She is noted for the owl figures (Fig. 9) which have been produced at Zuni since the 1880s. Nellie may be the only potter of the previous generation whose work is known outside of her village. Although quite advanced in years, Nellie still fashions small owls and bowls which are painted by her granddaughters. As a girl Quanita watched her mother work when she came home from school in the afternoons but never helped her with the preparation of the clay. She learned in the forties. As is true for most of the arts at Zuni, pottery is a family affair with various members participating according to their abilities. Jack, Quanita's husband also came from a pottery making family and learned from his great grandmother. The husband and wife team fashion the larger pots. Quanita's daughters Erma Jean Homer and Roweena Lemention with their husbands Fabian and Fernandez do a lot of the pottery painting. Three other daughters also make pottery from time to time, but not seriously at the present. Quanita's husband, Jack, is in charge of the firing and has constructed a beautiful rectangular kiln on the family sheep ranch north of the main village. Jack is a meticulous craftsman and built his kiln accordingly in contrast to the usual haphazard pit with metal grates. Like most of the potters at Zuni, the Kalestewas use sheep manure as fuel, rather than the cow manure typical of Rio Grande Pueblo firings.

24

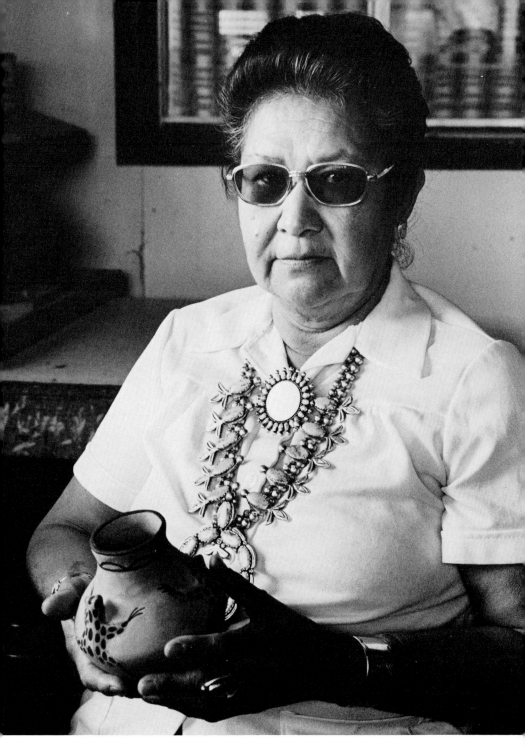

Figure 8. Quanita Kalestewa. Photo by James Ostler.

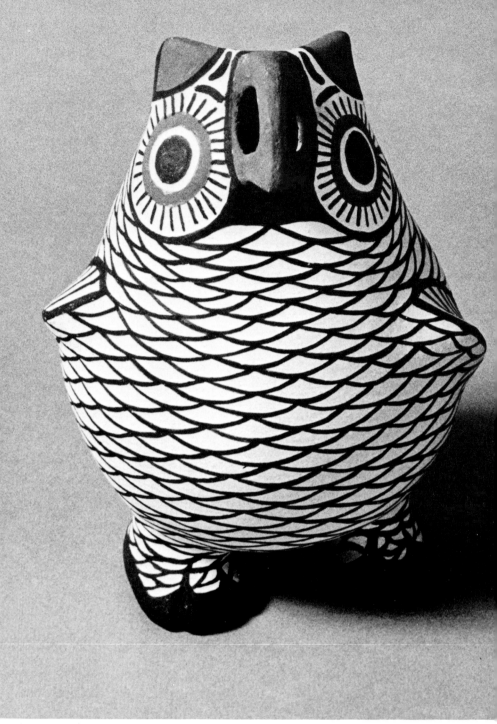

Figure 9. Owl figure on left by Quanita Kalestewa, that on right by Nellie Bica and Erma Homer. Photo by Michael Mouchette.

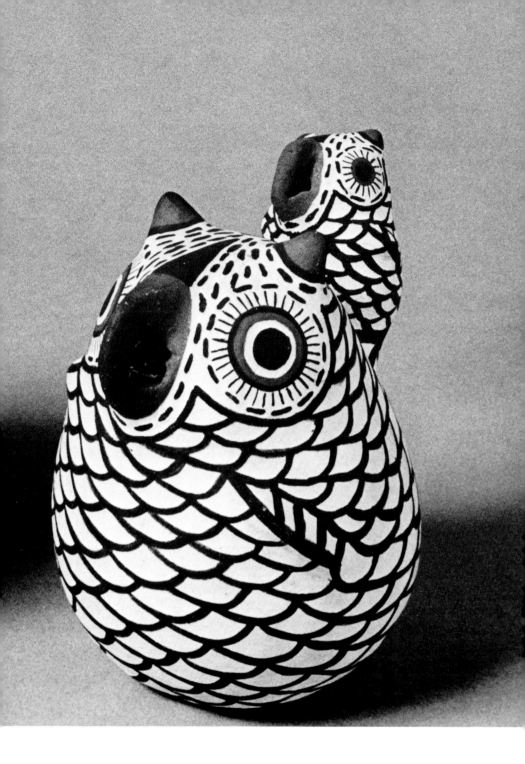

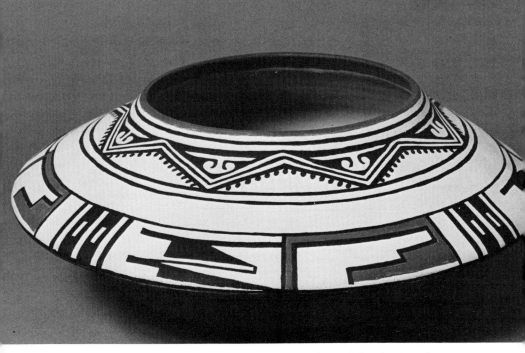

Figure 10. Jar, Jack Kalestewa. Photo by Michael Mouchette.

An important characteristic of Kalestewa family pottery cannot be seen in a photograph and that is its thinness. When asked why their pots were thinner and lighter than those of the other Zunis, Quanita laughed and replied that she was stingy with her clay. Like many of the potters of the village the family gets its clay from Nutria mesa. It is a laborious job and most potters go once a year for their clay supply. Cleaning and mixing is a long, unpleasant job too. Crushed potsherds provide the temper and these must be ground with a metate and mano. Pots that break in the kiln can be used for temper. The red areas are made with a deep yellow ochre (limonite) which turns red in firing. Apparently this ochre is becoming rare at Zuni and the family treasures the coffee can full they have at present. Black is made from cakes of boiled wild mustard or beeweed. The white clay (kaolin) for the base slip can be obtained locally, but the Kalestewas get theirs from Acoma, which also explains the greater intensity of their white.

The Kalestewas pride themselves on using only traditional Zuni designs. The one they use most is "The Deer In His House" (Fig. 22). There is some resentment of the fact that potters from the other Pueblos use the distinctively Zuni deer with a heartline. They themselves would never borrow designs from the other Pueblos. Another favorite is the ceremonial bowl illustrated in

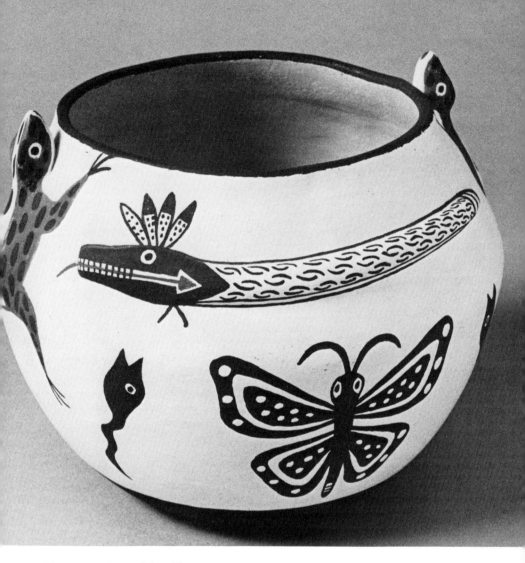

Figure 11. Pot with relief frogs, Jack Kalestewa. Photo by Michael Mouchette.

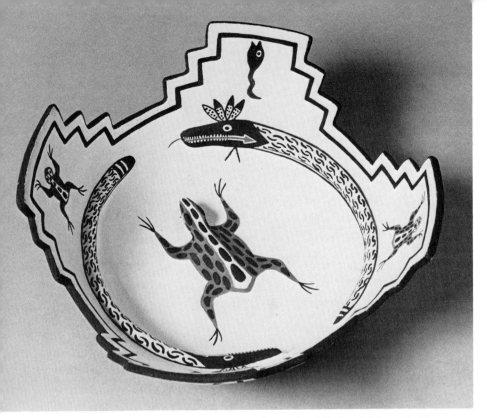

Figure 12. Bowl, Jack Kalestewa. Photo by Michael Mouchette.

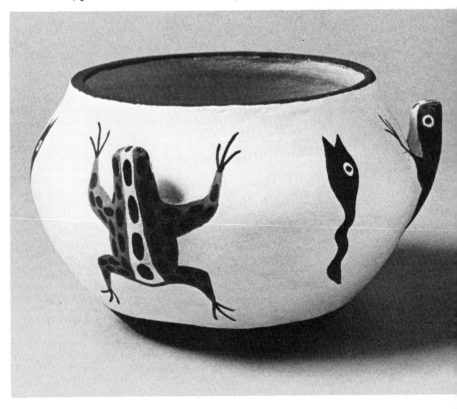

Pottery Treasures by Jerry Jacka. They keep a copy of this book in the workroom for design ideas from older pots. This bowl with the serpent *kolowisi* circling the center is used as an inspiration for other bowls with the serpent painted or modelled in three dimensions going around the interior or exterior. Another favorite is the rare Hawikuh polychrome bowl dated to c. 1600 in the School of American Research. (Fig. 23) Jack Kalestewa has done several pots based on slides provided by the school. (Fig. 10) This steep shouldered jar form has not been made at Zuni for generations. Other books they keep in the workroom are *Gifts of Mother Earth* by Margaret Hardin and Jack Barry's *American Indian Pottery*. Also, the Smithsonian has sent them a series of black and white photographs of fine pots from their collection. It should be noted that these modern bowls are not copies of the older ones but rather interpretations different in many details.

&&&&&&&&&&&

Figure 13. Jar on left by Quanita Kalestewa, jar on right by Nellie Bica and Erma Homer. Photo by Michael Mouchette.

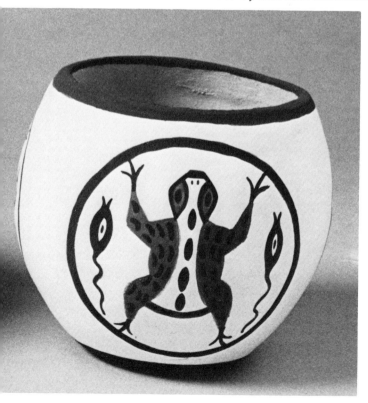

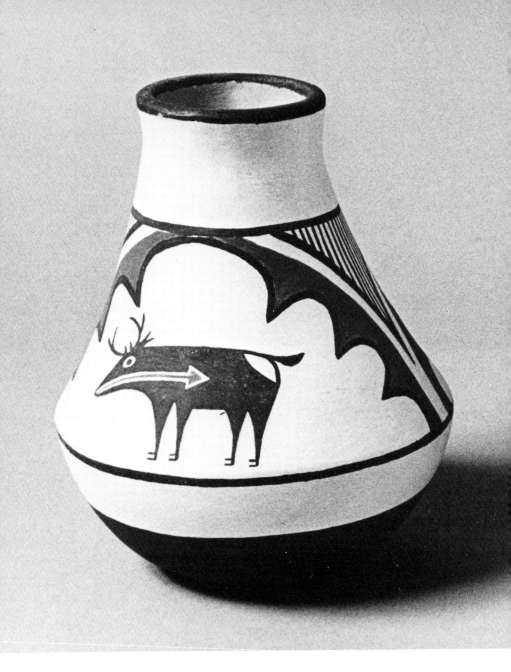

Figure 14. Kiva water bottle on left by Nellie Bica and Jack Kalestewa, bowl on right by Jack Kalestewa. Photo by Michael Mouchette.

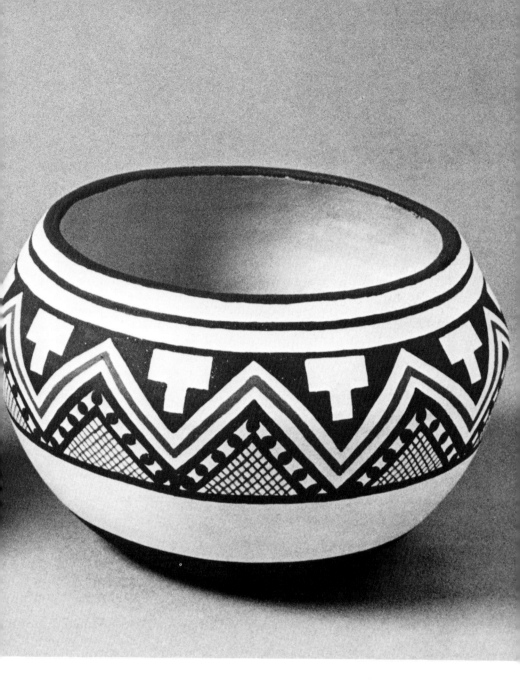

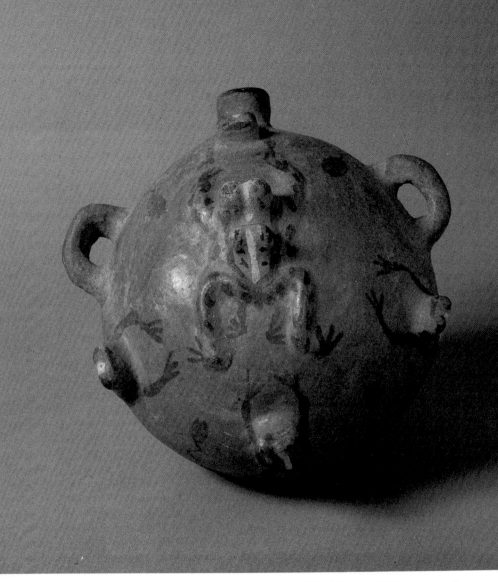

Figure 15. Canteen with frogs. c. 1880-1900. Maxwell Museum of Anthropology. Photo by Michael Mouchette.

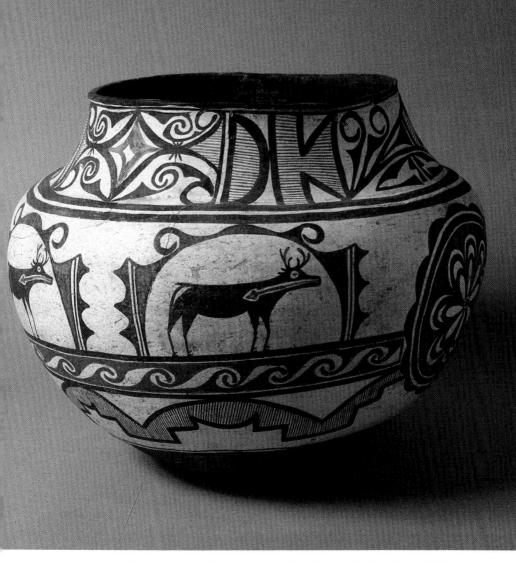

Figure 16. Water jar with "Deer in His House" Motif. c. 1900.
Maxwell Museum of Anthropology. Photo by Michael Mouchette.

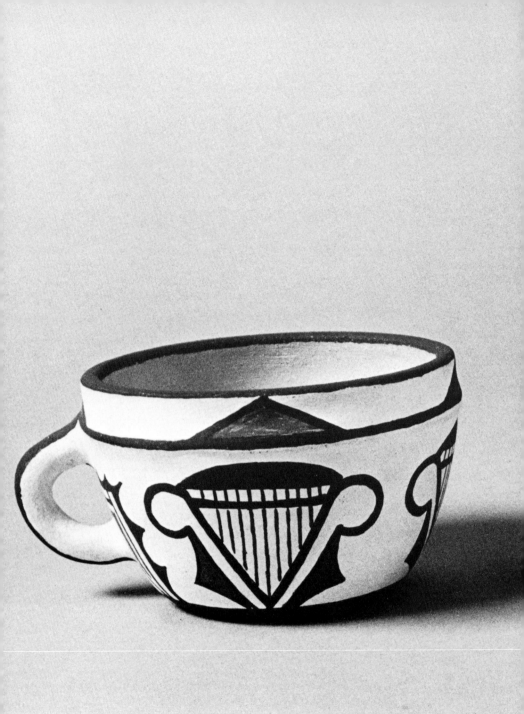

Figure 17. Cup by Jack Kalestewa, condiment dish in center by Nellie Bica, bear on right by Jack Kalestewa. Photo by Michael Mouchette.

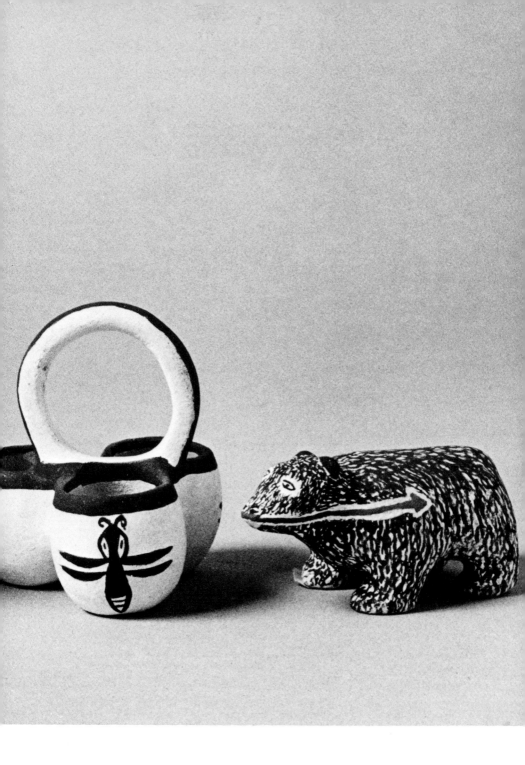

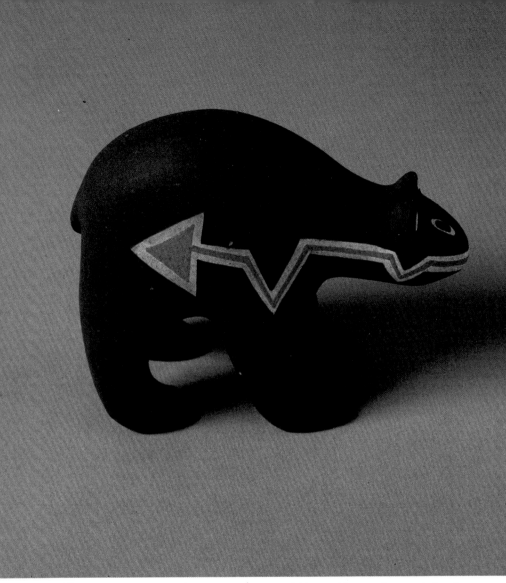

Figure 18. Bear figure, Rowena Him. Photo by Michael Mouchette.

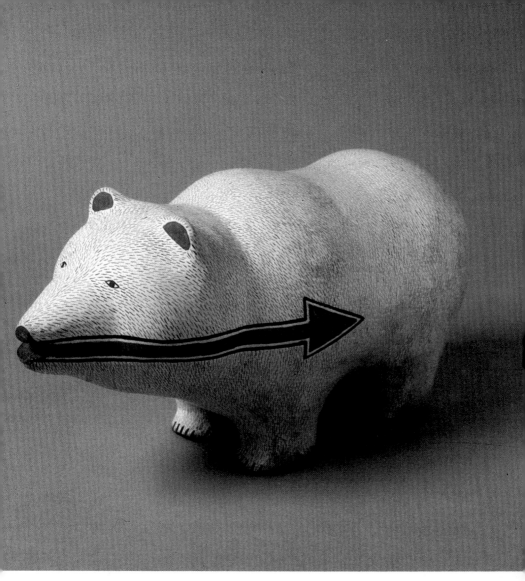

Figure 19. Bear figure, Fabian Homer. Photo by Michael Mouchette.

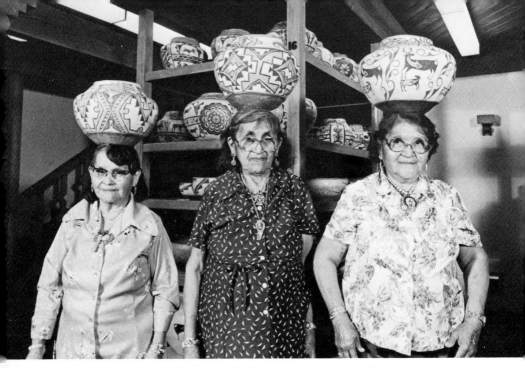

Figure 20. Josephine Nahohai in center and Olla Maidens, Rose Gasper and Eloise Westika, "trying on" water jars in the collection of the School of American Research.

Josephine Nahohai, the family matriarch, was given a grant by the School of American Research to teach other women at Zuni how to pot. About six to eight women started out in her class, but when they found out they would have to gather, clean and mix the temper for their own pots—that it was not to be like going to a trader and buying silver sheets and wire—all but two women dropped out. Fig. 20 shows Josephine with two friends, members of the Zuni olla maiden dance group, "trying on" their favorite pots in the SAR collection. (Fig. 20) Josephine and her family go once a year to get a pickup truck load of clay from the mesa. The white slip she gets from a friend at Laguna. The Zuni Archaeological Project, a tribal contract archaeology firm, gave the family a large box of prehistoric potsherds. While visiting the Smithsonian she and her son Milford became interested in finding the mineral that would give the rich turquoise found on many of the old pots. Geologists at the Smithsonian forwarded some mineral samples which they feel will achieve the desired result and Josephine will soon try them out. The Kalestewa family also is interested in trying to reproduce this old blue green on their pottery. Although black is obtained here with wild

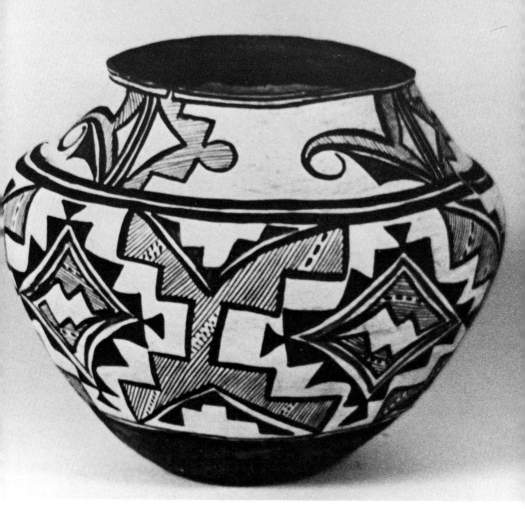

Figure 21. Josephine Nahohai's favorite jar at the School of American Research, c. 1900-1920. Indian Arts Fund, School of American Research.

mustard or beeweed plus a small amount of the ground mineral hematite, the geologists also sent samples of minerals that would produce a black paint when fired.

Milford Nahohai paints his mother's pottery and makes pieces of his own. (Fig. 25) However, he is also employed as Wholesale Manager of the Pueblo of Zuni Arts and Crafts so he has little time to work on his own pots. In addition to working in the store, he also travels around the country promoting Zuni arts. His pottery sits about his work area in various stages of completion. Milford has been especially fascinated by the older pottery in museums.

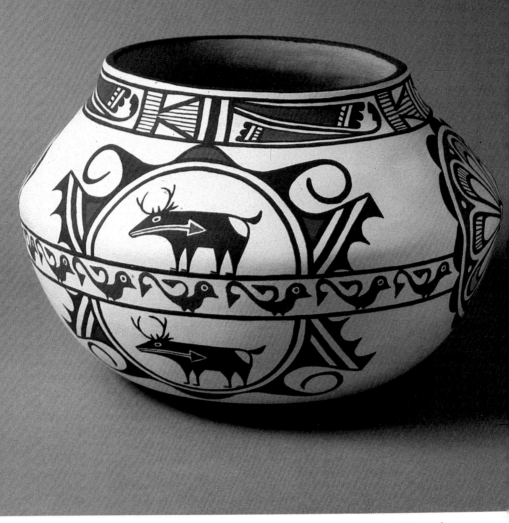

Figure 22. "Deer in His House" jar, Jack Kalestewa. Photo by Michael Mouchette.

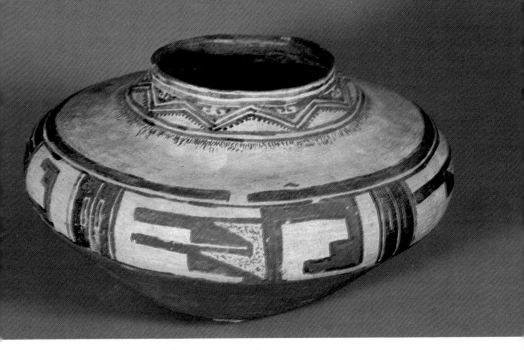

Figure 23. Hawikuh glaze polychrome jar, c. 1600-1660. Indian Arts Fund, School of American Research.

Figure 24. Josephine Nahohai demonstrating pottery painting. Photo by James Ostler.

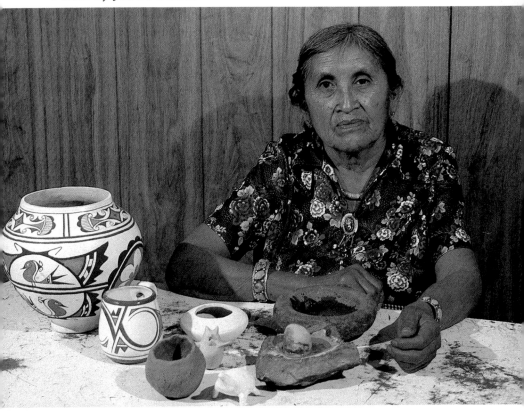

Figure 25. Milford Nahohai standing in front of firing materials. Photo by James Ostler.

44

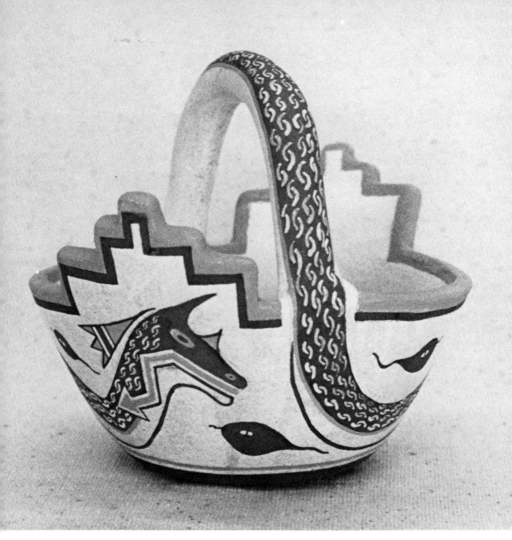

Figure 26. Corn meal bowl with handle in form of "kolowisi" serpent, Milford Nahohai. Photo by James Ostler.

He was making a version of a corn meal bowl with a *kolowisi* as a handle as seen in the Maxwell Museum (Fig. 26). As a result of seeing older pottery with no white slip, Josephine and Milford have begun to make unslipped wares (Fig. 27). The clay fires to a rich red color, actually very similar to some Hopi pot types. Many of Milford's pots have turtles modeled on them which he explained was a result of his father's clan which is water, therefore all water creatures are his brothers. He and his brother, Randy also use textures on their pottery inspired by the sherds and other prehistoric utility wares they saw in museum

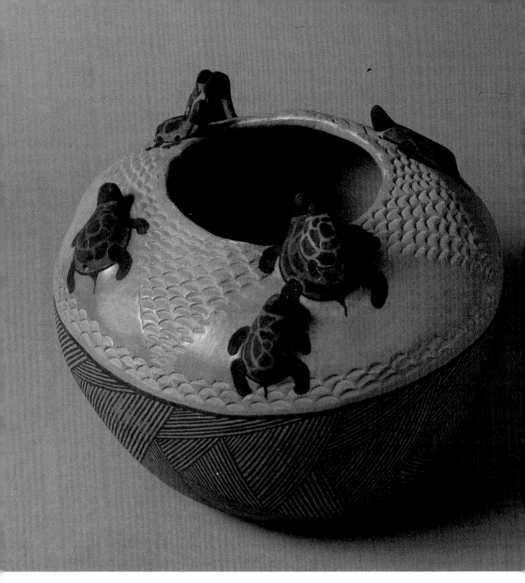

Figure 27. Turtle effigy pot, Josephine and Milford Nahohai.
Photo by Michael Mouchette.

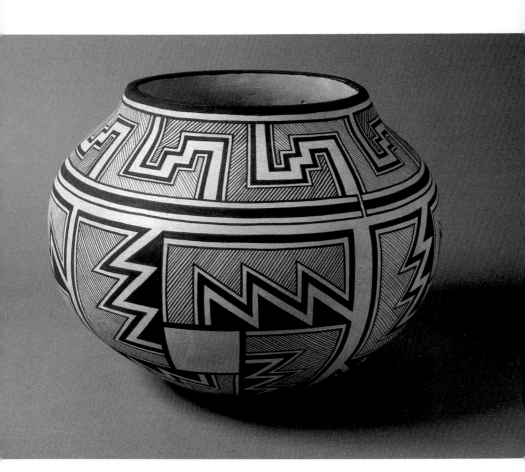

Figure 28. Jar, Randy Nahohai. Photo by Michael Mouchette.

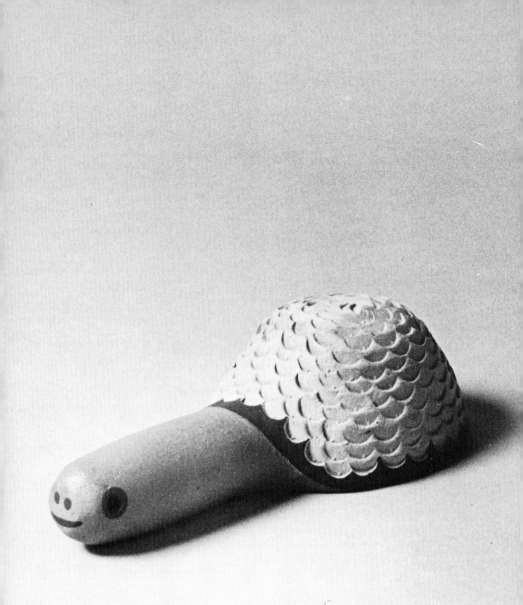

*Figure 29. Turtle ladle and jar, Josephine and Milford Nahohai.
Photo by Michael Mouchette.*

collections. The indentations are made with the end of a stick. As
a result of seeing old corrugated ladles in the museums he and his
mother made one and when he saw it lying with the convex side
up it reminded him of a turtle and he put a face on the handle
(Fig. 29). Milford wants to learn much more about the history of
Zuni pottery both for his own personal interest and so he can

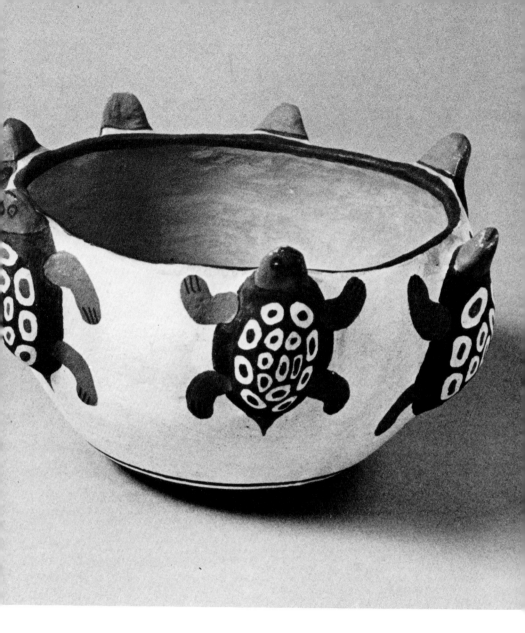

represent it better when he travels on behalf of the business. Already his increased knowledge has led the Nahohai family to reintroduce the "spirit break" or broken line on the rim of Zuni pottery, a tradition that had been forgotten. Now other potters are taking up this old custom. (It was thought in the past that if a potter closed the painted line on the rim of a pot that his or her life

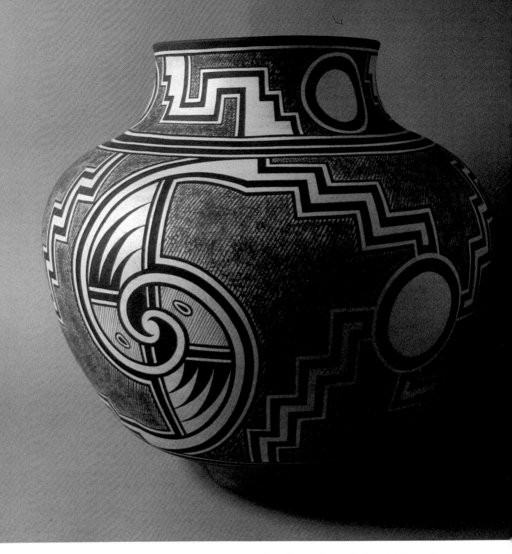

Figure 30. Jar, Randy Nahohai. Photo by Michael Mouchette.

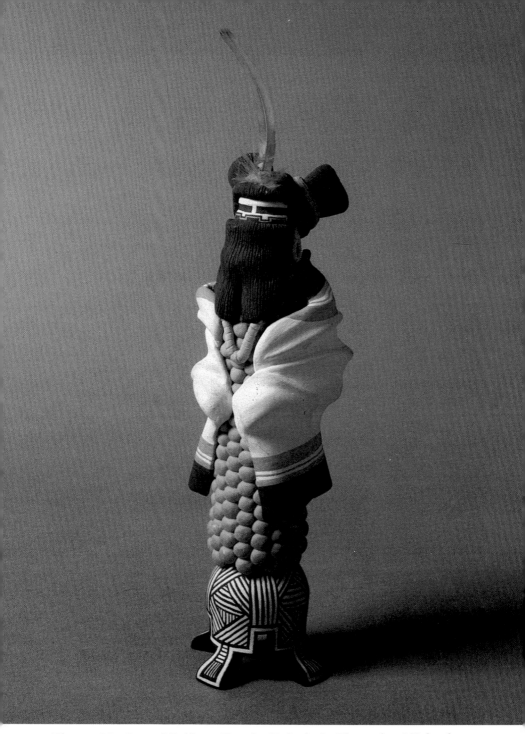

Figure 31. Corn Maiden, Randy Nahohai. Photo by Michael Mouchette.

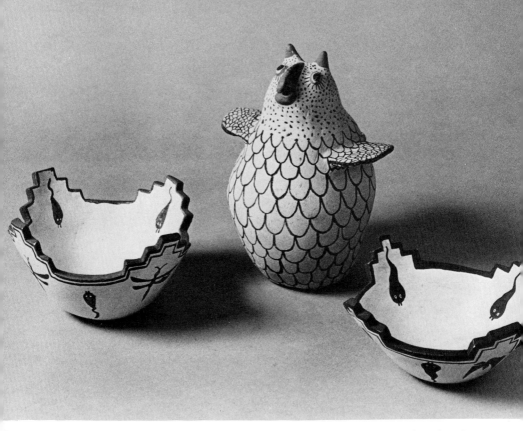

Figure 32. Owl by Josephine Nahohai, corn meal bowl on left by Josephine's daughter, Priscilla Tsethlikai, bowl on right by Josephine. Photo by Michael Mouchette.

would be completed or end also.) The Nahohais have also reintroduced the custom of keeping a traditionally fired water jar around the kitchen. Many of their Zuni friends agreed that water stored this way had a better taste.

Randy Nahohai (Fig. 33) and his wife Rowena Him (Fig. 36) live outside the village in a new home in Black Rock with their baby, J.C. Randy began three years ago by painting his mother's pottery after his father stopped doing so because of poor vision. He then began painting greenware, that is commercially moulded ceramics purchased in a shop, and using highfired glazes. Next he started shaving clay off of the moulded pieces and fashioning small figures on his own from the clay scraps. The next step naturally was learning to make traditional pottery from scratch. Randy has more formal art training than any of the other Zuni potters as he is a recent graduate of the Institute of American Indian Arts in Santa Fe where he majored in two-dimensional art.

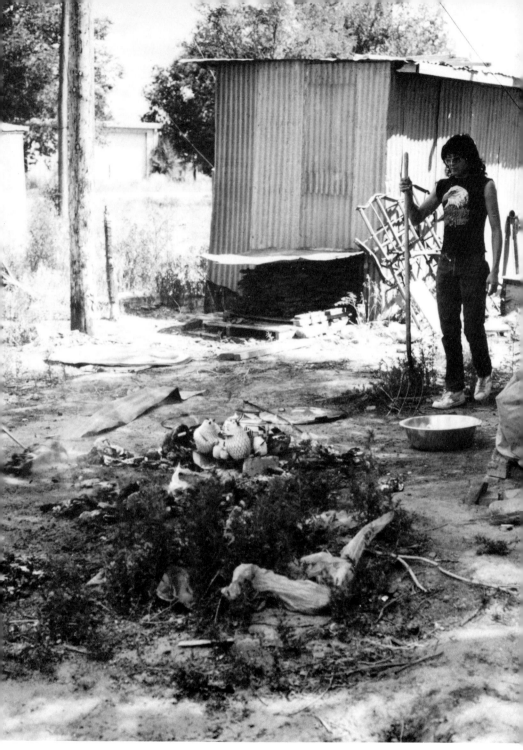

Figure 33. Randy Nahohai firing pottery. Photo by James Ostler.

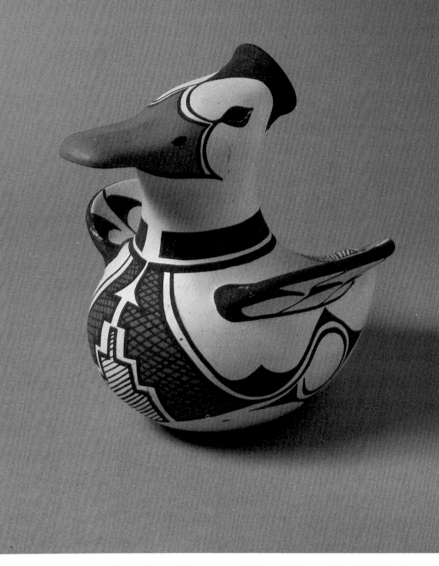

Figure 34. Duck effigy, Rowena Him. Photo by Michael Mouchette.

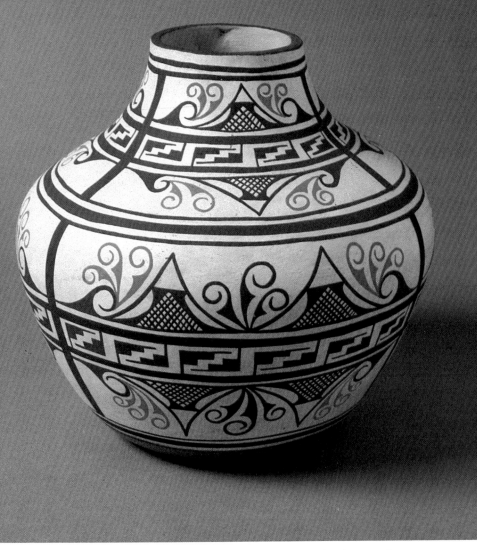

Figure 35. Jar, Rowena Him. Photo by Michael Mouchette.

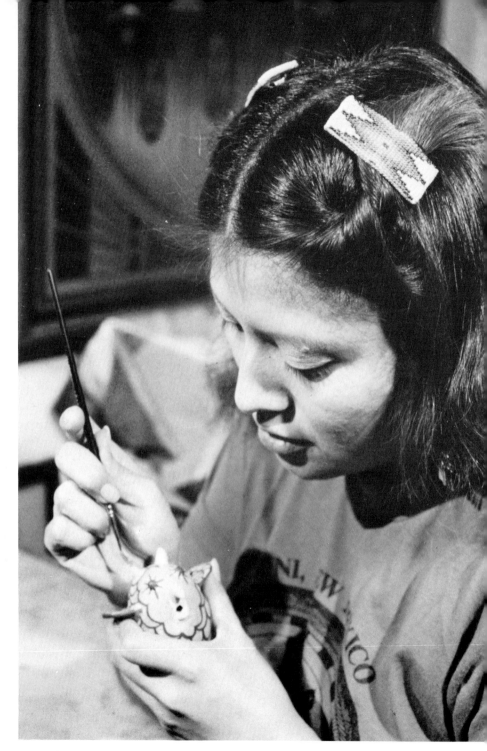

Figure 36. Rowena Him painting owl. Photo by James Ostler.

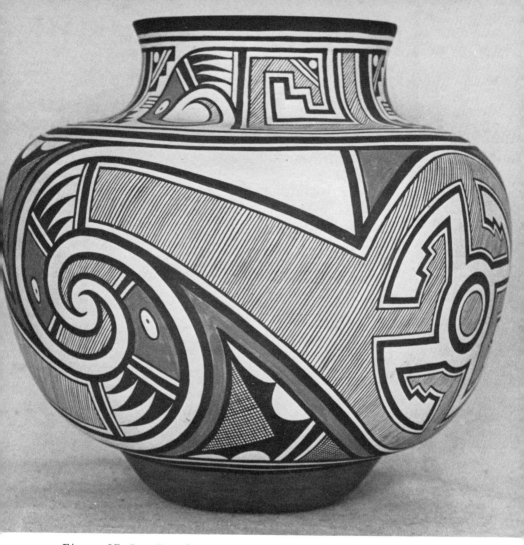

Figure 37. Jar, Randy Nahohai. Photo by Michael Mouchette.

In school he was required to keep a sketch book with drawings representing various stages of his training and he has continued this practice by adding drawings of Zuni pottery designs from various museum collections. Randy is especially fond of the very angular geometric pottery with areas filled with fine lines (Figs. 28, 30, 37, 40) He and his brother Milford admire the design called "rainbird" by H.P. Mera. (Fig. 4) Milford believes the design represents the rainbearing cumulus clouds seen in profile as they roll into the Zuni Valley. The forward edges of the clouds roll under the main mass, producing a curve similar to that of a bird's beak, hence the term "rainbird". Both Milford and Randy enjoy putting the textures on their pottery.

57

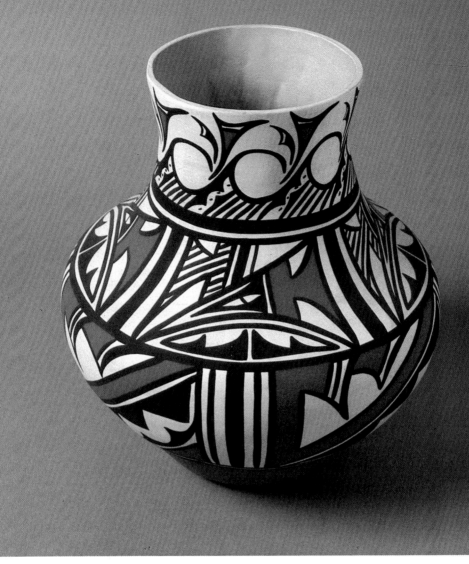

Figure 38. Jar, Priscilla Peynetsa. Photo by Michael Mouchette.

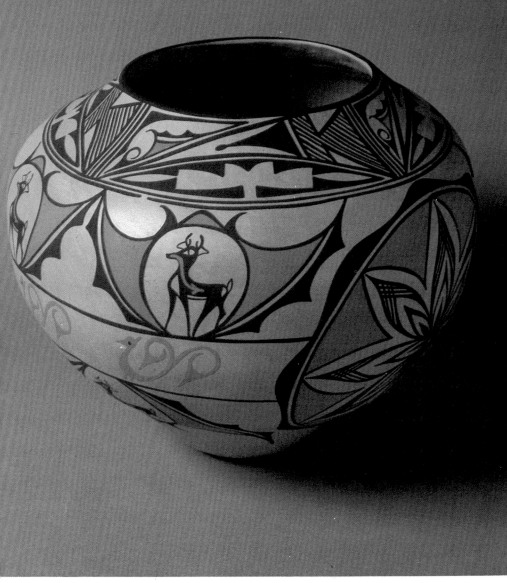

Figure 39. Jar, Anderson Peynetsa. Photo by Michael Mouchette.

Figure 40. Jar, Randy Nahohai. Photo by Michael Mouchette.

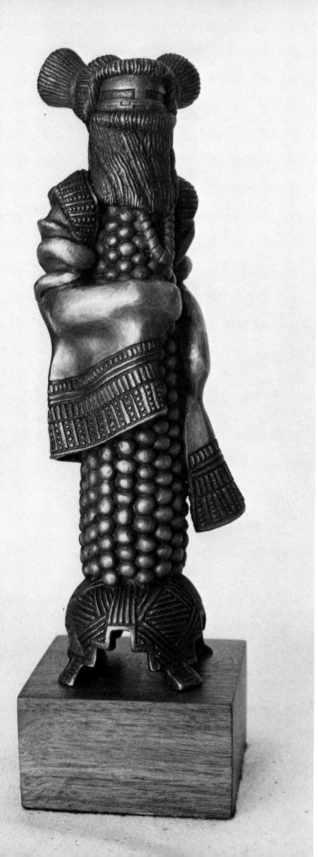

Figure 41. Bronze figure based on Corn Maiden in Figure 31, Randy Nahohai. Photo by James Ostler.

Figure 42. Jar with kolowisi *in relief, Anderson Peynetsa. Photo by Michael Mouchette.*

Figure 43. Dough bowl, Loubert Sooseah. Photo by Michael Mouchette.

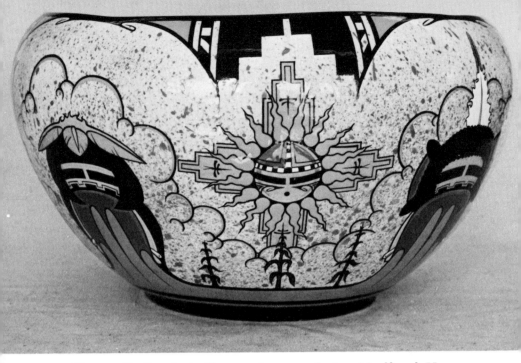

Figure 45. Bowl similar to those made for Mudhead House. Slipcast and glazed, Randy Nahohai. Photo by James Ostler.

Last year Randy Nahohai's sister sponsored the Mudhead Houses. This important religious obligation among other things meant providing the bowls used by the Mudheads. Randy made six large bowls for the society and although he painted them with traditional Zuni bowl designs he used commercial greenware. Fig. 45 shows one similar to the Mudhead bowls which he made for his mother. Another greenware bowl he painted with imaginative designs drawn from Zuni religious imagery and gave to his brother Milford as a Christmas present.

Although two other Nahohai daughters, Irene and Priscilla, make pots occasionally, Josephine's two sons and one daughter-in-law are the primary bearers of the family tradition. Randy fully intends to restore Zuni pottery to the creative level of one hundred years ago, by taking the old designs and reinterpreting them with taste and flare. In the last century Zuni was known for the great innovations of its potters.

Many young potters have learned their skills not within their families, although many did have someone knowledgeable to teach them, but in the Zuni High School art program. These courses, beginning, intermediate and advanced are taught by Jennie Laate. (Fig. 47) Jennie was born at Acoma, a Pueblo

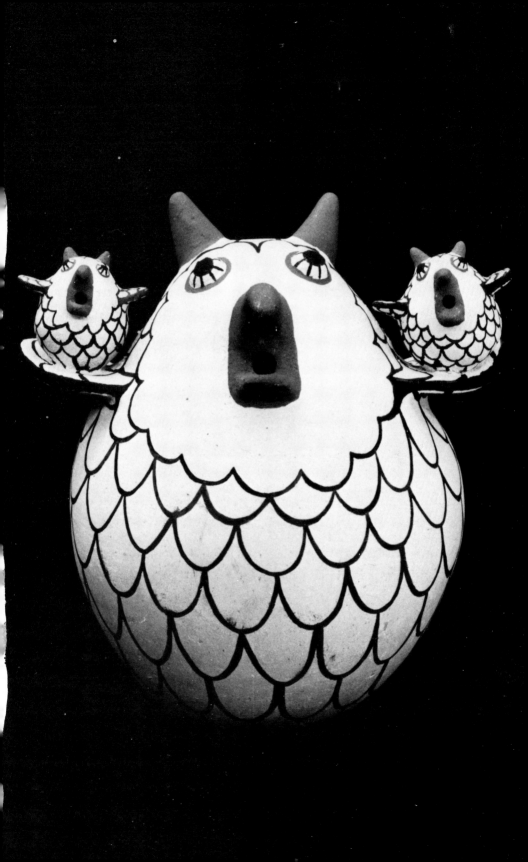

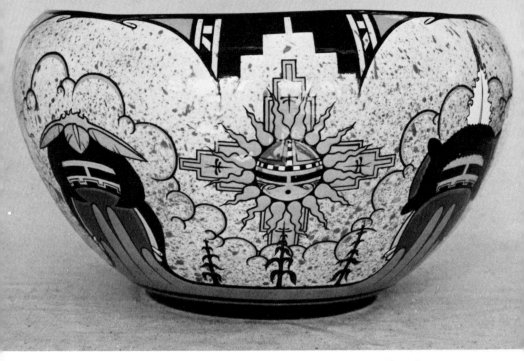

Figure 45. Bowl similar to those made for Mudhead House. Slipcast and glazed, Randy Nahohai. Photo by James Ostler.

Last year Randy Nahohai's sister sponsored the Mudhead Houses. This important religious obligation among other things meant providing the bowls used by the Mudheads. Randy made six large bowls for the society and although he painted them with traditional Zuni bowl designs he used commercial greenware. Fig. 45 shows one similar to the Mudhead bowls which he made for his mother. Another greenware bowl he painted with imaginative designs drawn from Zuni religious imagery and gave to his brother Milford as a Christmas present.

Although two other Nahohai daughters, Irene and Priscilla, make pots occasionally, Josephine's two sons and one daughter-in-law are the primary bearers of the family tradition. Randy fully intends to restore Zuni pottery to the creative level of one hundred years ago, by taking the old designs and reinterpreting them with taste and flare. In the last century Zuni was known for the great innovations of its potters.

Many young potters have learned their skills not within their families, although many did have someone knowledgeable to teach them, but in the Zuni High School art program. These courses, beginning, intermediate and advanced are taught by Jennie Laate. (Fig. 47) Jennie was born at Acoma, a Pueblo

66

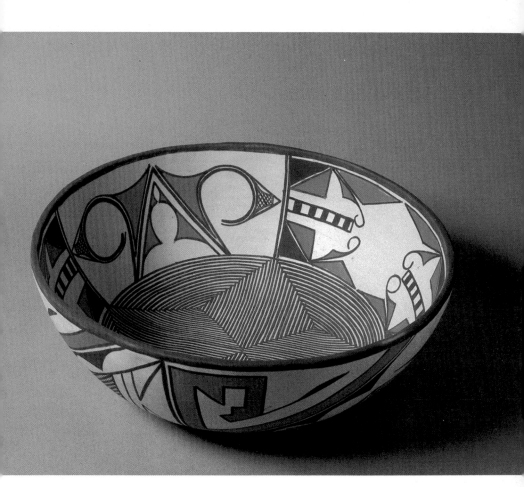

Figure 43. Dough bowl, Loubert Sooseah. Photo by Michael Mouchette.

Once Randy took up traditional pottery making he threw his entire artistic effort into the project. He is making increasingly larger pots as he experiments with sculptural shapes. He forms a sharper bottom to his jars in contrast to the usual rather squat flat bottoms of other potters. He thinks the others' pots are flatter because they use a *puki* or preformed base for their pots. He brings up the base slowly until he feels that the outward curve of the base can support the heavier shoulder. Randy's largest jar to date is one seventeen inches both in height and diameter (Fig. 30), but his goal is to make one about three feet tall. Randy's gradual involvement with all the processes of pottery has led him in a circle back to European type figural sculpture in the form of ceramic molds of a Zuni corn being which will be used for a limited edition of bronze castings. (Figs. 31 & 41). He also hopes to soon begin carving in alabaster. Although Randy uses traditional Zuni methods and materials of manufacture he usually does not fire his pots in the open manure fire his mother and brother use. Instead he takes them to a professional ceramic workshop in Gallup and has them fired in the electric kiln there. He seems to feel that there is less risk of the pieces breaking in the electric kiln during this crucial and dangerous phase.

Randy's wife, Rowena Him, has begun making pottery under the influence of her husband and mother-in-law. Rowena's mother painted greenware pots from time to time, but did not teach her daughter. Randy sketches out pots for her, and did several views of the duck pot (Fig. 34) which is based on one in the Smithsonian Institution and illustrated in *Gifts of Mother Earth* (Fig. 55). Although she makes vessels, Rowena seems to prefer three dimensional figures especially owls and bears. For a while she was making small owls and piercing and stringing them with silver wire for use in jewelry. Rowena's bears come in all sizes and resemble some of the carved fetishes with the Zuni heartline running from the bear's mouth to heart and lungs. (Fig. 18) Rowena's owls have the same style eyes as the pieces made by her mother-in-law, Josephine, that is large and bulging with the "lashes" radiating like sunrays. (Figs. 44 and 32).

✦✦✦✦✦✦✦✦✦✦✦

Figure 44. Owl, Rowena Him. Photo by Michael Mouchette.

renowned for its fine, thin pottery with imaginative polychrome painting, but married a Zuni man. Jennie took over the high school program in 1975 from Daisy Nampeyo Hooe another woman from outside the village (in this case from Hopi) who married a Zuni native. She teaches only Zuni style pottery at the school. The classes all go out to dig their clay on a field trip. The mustard or beeweed that she laboriously boils up is a small treasure which she keeps locked in a drawer. Jennie had seventy-eight students in the fall of 1986, divided into six classes. This is quite an achievement, since pottery work requires so much individual attention. The large art classroom is shared with another who teaches belt weaving and painting and drawing.

Figure 46. Slipcast and glazed bowl made as Christmas present by Randy Nahohai for his brother Milford. Photo by James Ostler.

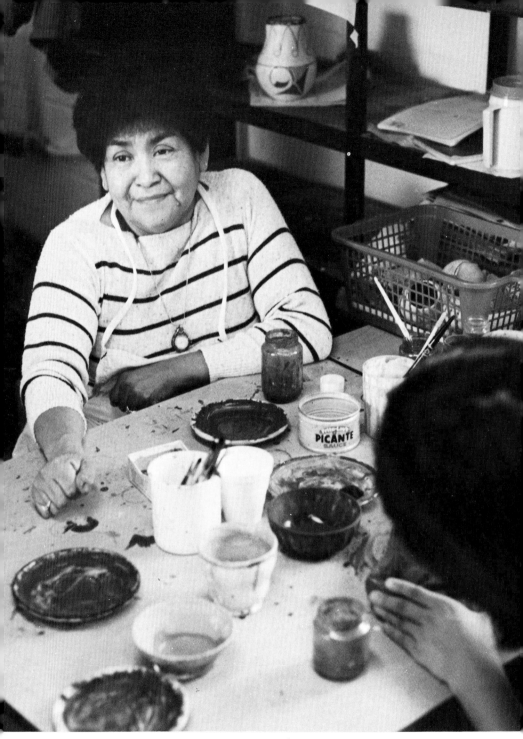

Figure 47. Jennie Laate in classroom with painting materials in front of her and electric kiln in background. Photo by James Ostler.

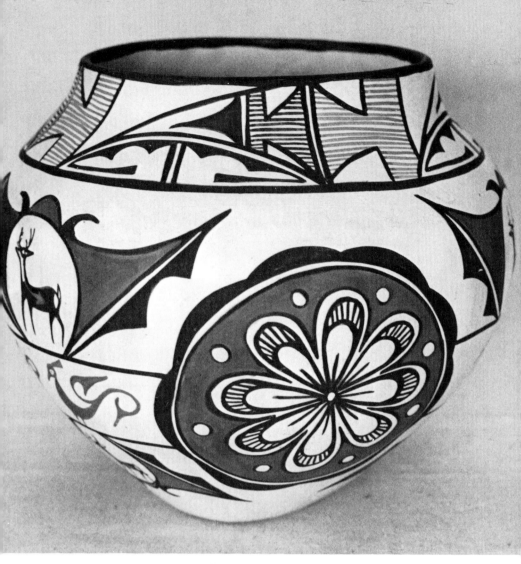

Figure 48. Jar, Jennie Laate. Photo by James Ostler.

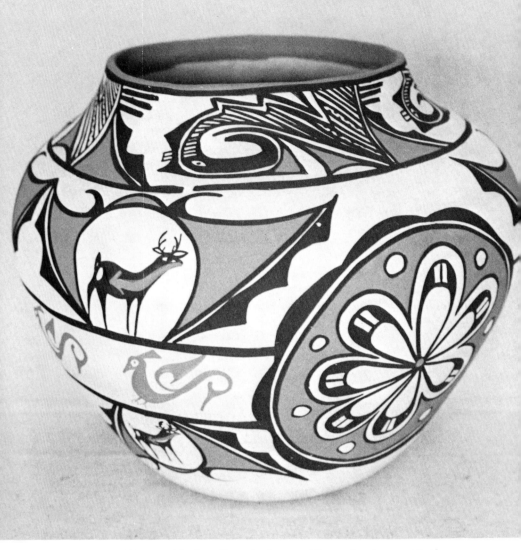

Figure 49. Jar, Jennie Laate. Photo by James Ostler.

The equipment is simple with tools, especially paddles for shaping the pots, made by the high school woodworking classes. The redwood scrapers and small turntables are bought from school supply catalogs. There are two electric kilns in the classroom which used to be shared with the potters in the community but this is no longer possible with so many students enrolled in the pottery class. Beginning students make tiny "pinchpots" and go on to owls while Intermediate students add larger pots to the repertory and advanced students are free to experiment. Jennie patiently goes about the classroom giving individual advice. "Don't paint the handle of the pitcher until the very last since it is likely to smear. Don't open up the owl figure (put a hole in the bottom) until the last minute since it might collapse." Note: the owls are generally modelled in two halves and put together and the hole is poked into the bottom to insure that they will not explode in the kiln.

Jennie has a sheaf of photographs under plastic of older pots from museum collections as well as books for the students to use as reference. She believes the students should only use really traditional Zuni designs and that is what she teaches. Her own pots are completely in the Zuni style and of two main types, jars with "The Deer in His House" motif and jars with modelled frogs (Figs. 48-49). Her deer do not usually have the white outline around the heartline which other potters use. She said she finds it difficult to make the flatter bottoms of twentieth century Zuni jars and most of hers are all more pointed on the bottom as is typical of modern Acoma pots. It can be seen that most of her students also use the pointed tapered shape which she taught in class (Fig. 39)

Every year at Christmas time there is an arts and crafts fair at the high school. Many of the high school and other government employees eagerly attend this fair and sale and quickly buy all the best pieces. Fig. 58 shows Jennie and a student preparing a group of student pots for the 1986 crafts show at the high school.

A number of Jennie Laate's students have continued to make pottery after high school but she does not know why they do not keep it up very long. Anderson and Priscilla Peynetsa are a talented brother and sister who share a similar style. Priscilla (Fig. 50) took a class in high school, but was not interested in pottery at that time. Later she had an accident and was unable to work for a while and then had to stay home to take care of her grandmother. Only at that time did she go back to evening school and learned pottery in earnest. She makes her pots in the old manner except that she uses an electric kiln for the firing unless

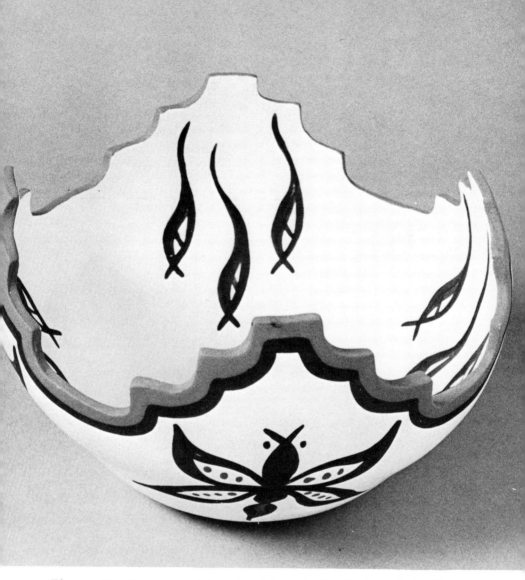

Figure 51. Corn meal bowl with tadpole design, Priscilla Peynetsa. Photo by Michael Mouchette.

Figure 50. Priscilla Peynetsa. Photo by James Ostler.

73

someone especially asks for a completely traditional pot. Then she asks a friend for help in doing an open firing. She and Anderson have a bold, flowing style of painting which is immediately identifiable. They both use large solid areas of red paint, where most Zuni potters use red more sparingly. Anderson prefers the sculpting, especially of the relief figures on the pottery (Fig. 42) and the painting, frequently not taking as much care with the details of pot finishing as his sister. However, he may be the more innovative of the two. Priscilla prefers a rather long necked jar form, (Fig. 38) and also says she is the only one making pottery necklaces at Zuni. (Fig. 52) She saw one in a book, made at another Pueblo, and decided to try it herself.

Loubert Sooseah (Fig. 55), although only nineteen and a recent high school graduate, shows special promise as a potter. He works a great deal with unslipped wares and has even done a large dough bowl (Fig. 43) a rather unusual choice with today's potters, although a completely traditional form. Loubert has a fine painting sense using a thin light white slip but his shapes are specially creative, as in the long necked jar and canteen (Fig. 57). Loubert also does larger forms than most other potters.

❧❧❧❧❧❧❧❧❧❧❧

Figure 52. Necklace of half-pots, Priscilla Peynetsa. Photo by Michael Mouchette.

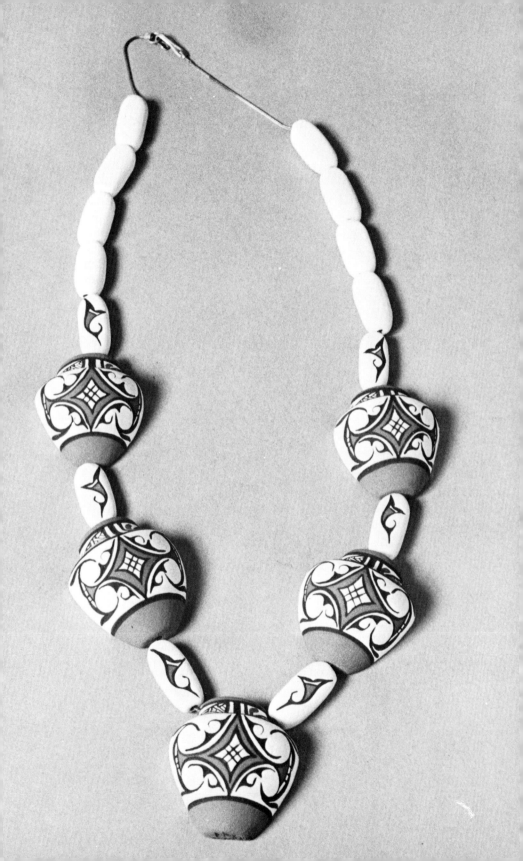

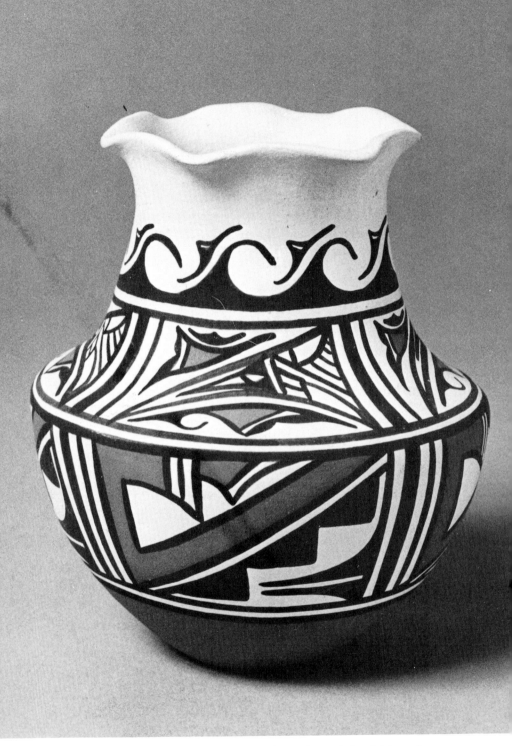

Figure 53. Jar, Priscilla Peynetsa. Photo by Michael Mouchette.

76

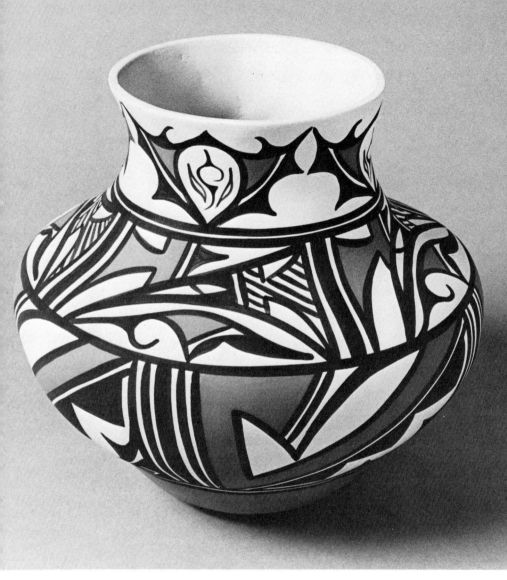

Figure 54. Jar, Priscilla Peynetsa. Photo by Michael Mouchette.

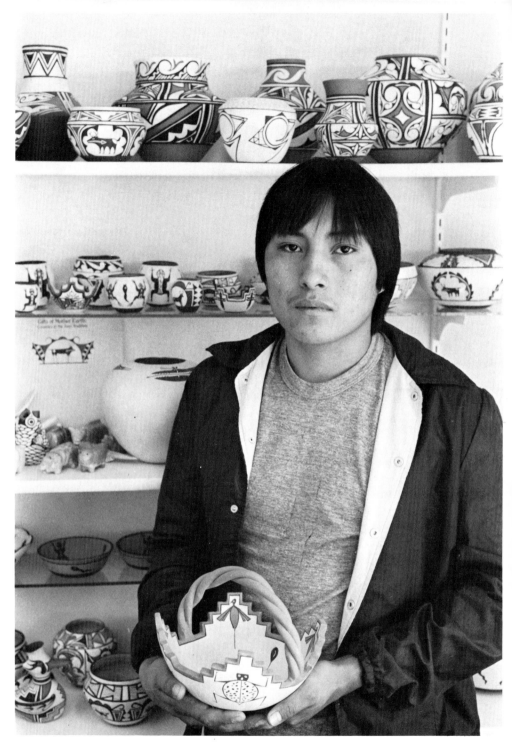

Figure 55. Loubert Sooseah. Photo by James Ostler.

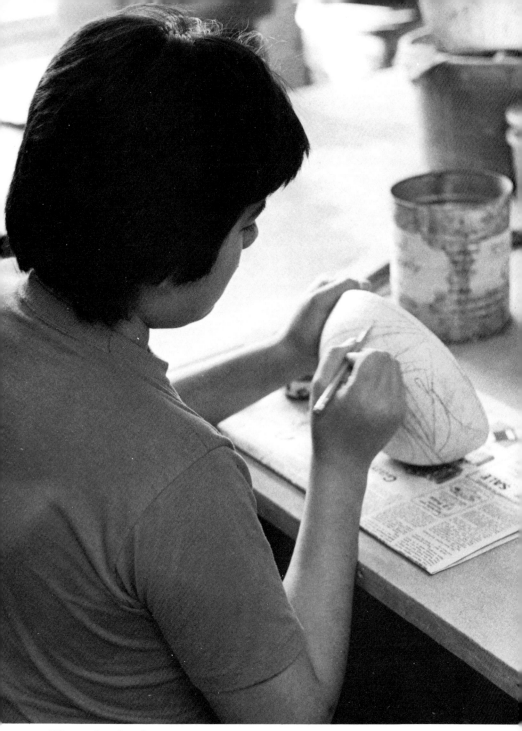

Figure 56. Student painting a pot. Notice the design is drawn in pencil first and then painted. Photo by James Ostler.

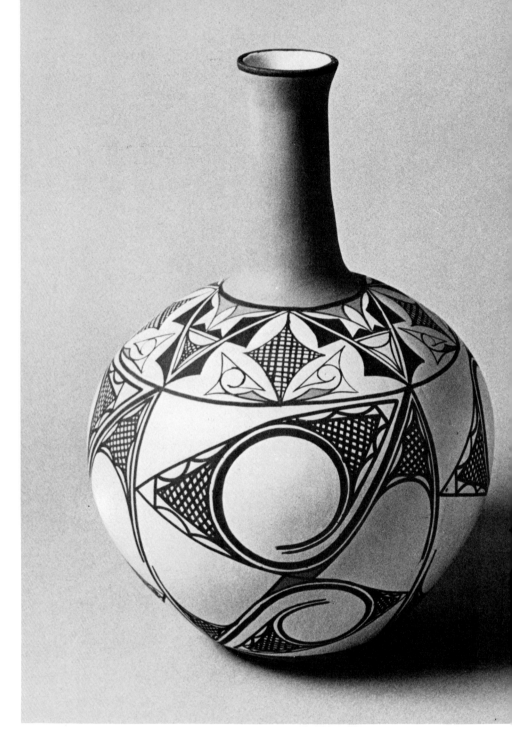

Figure 57. Long necked jar and Canteen, Loubert Sooseah. Photo by Michael Mouchette.

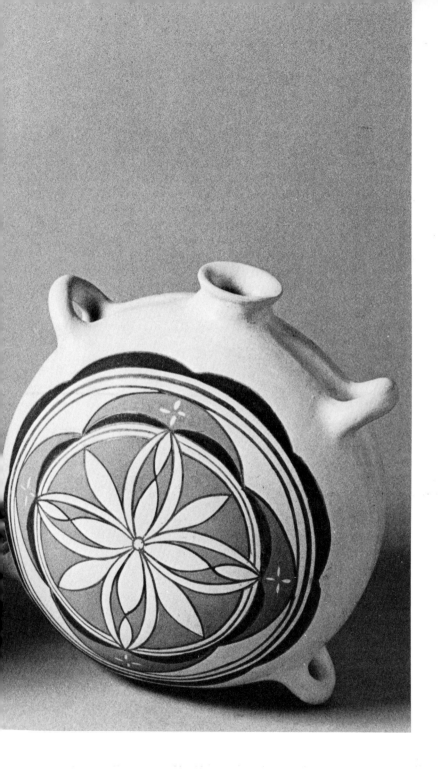

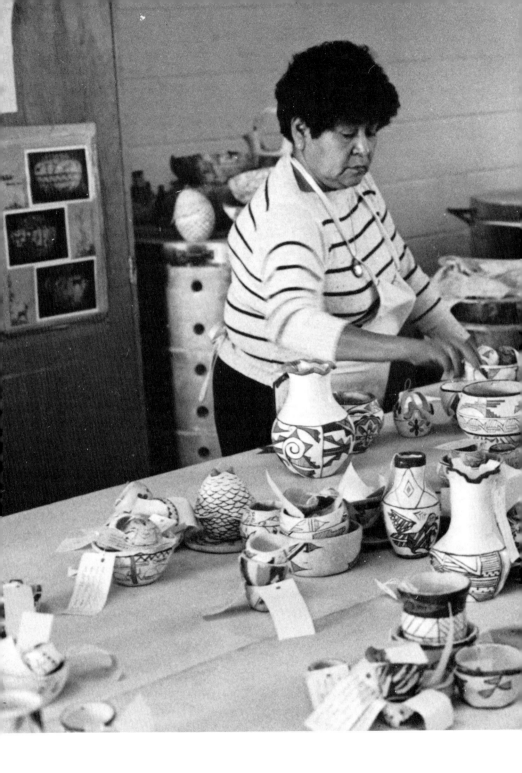

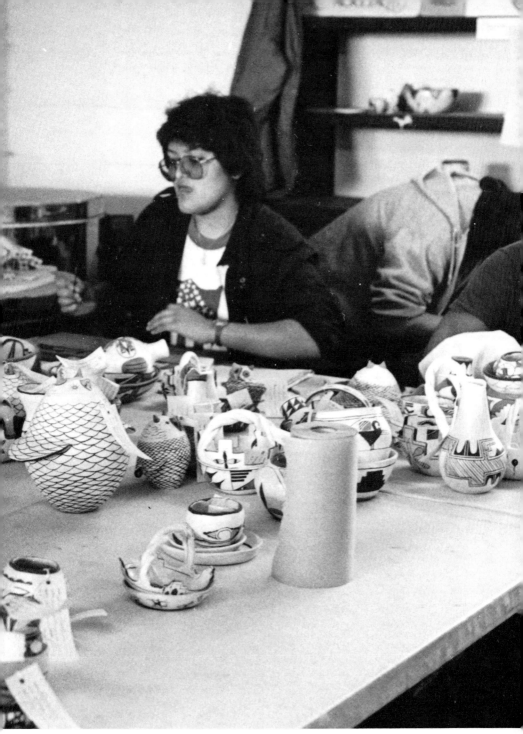

Figure 58. Jennie Laate and student assistant marking pottery for annual high school arts and crafts show. Photo by James Ostler.

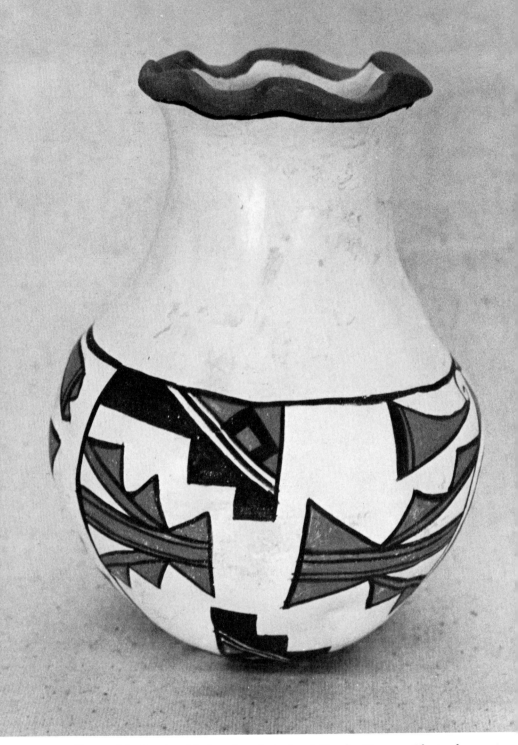

Figure 59. Jar by high school student Paula Quam. Photo by James Ostler.

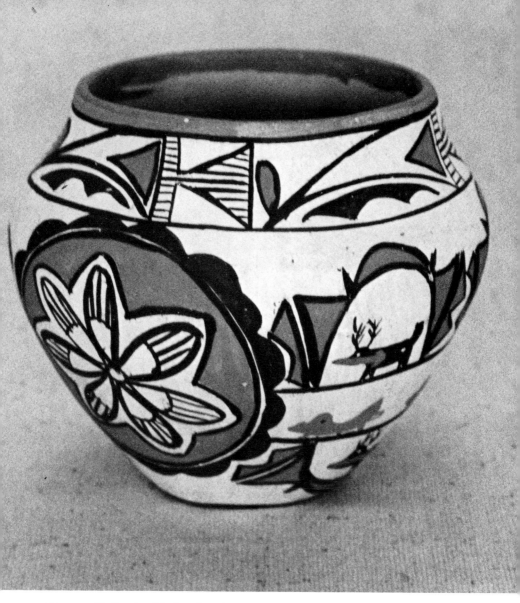

Figure 60. Jar by high school student, Ernestine Lucio. Photo by James Ostler.

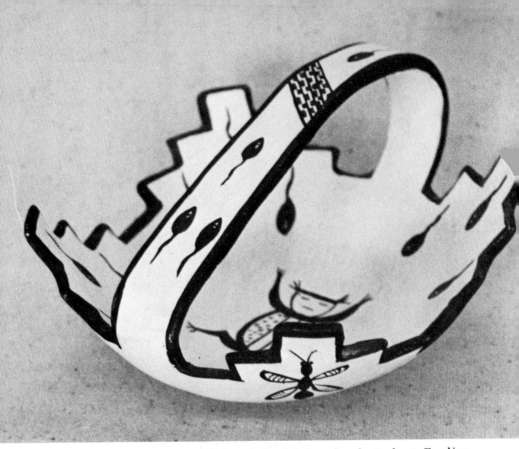

Figure 61. Corn meal bowl by high school student Evalina Boone. Photo by James Ostler.

The Genesis of a Zuni Pot

Frequently an art form can be better understood if the time each step takes the artist is examined. Two Zuni families were questioned about the time factors involved in their work and, although there are many variables, what does emerge is a striking feeling of just how time consuming traditional Pueblo pottery making is.

The Nahohai Family

The last time the family gathered clay from their favorite spot, a mesa about ten miles south of the village, they got two pickup truck loads which took four or five hours and involved ten people. The clay is dried for one or two days and when there is yellow mixed in, this is removed by hand. Next the clay is soaked in buckets of water for about one week until the water is a milky color. Then the clay is screened to separate out the small rocks, but the clay is not pressed or mashed as this might force small impurities along with the clay through the holes in the screening.

Temper is ground on the traditional corn grinding stones called *metates*. Both the time required and the amounts ground depend on the number of pots that will be made. For an average number of pots this may take four to five hours. Potsherds are used for temper, and as mentioned above the archaeological firm at Zuni gave the family a box of sherds, but before this they came from relatives and friends who found them when farming or herding. Sometimes they will exchange one of their pots for a quantity of sherds. Randy has experimented with various colored sands for artistic effect, but usually uses sherds. The clay is taken from the bucket and mixed by hand with the temper for one and a half hours until it is the right consistency. (This critical judgement comes from years of experience.) The clay is now ready to be shaped into pottery. Whatever is not needed is kept wrapped and moist in the bucket.

A medium sized pot of about nine inches in height takes about a half day for Milford to form and less for his mother. The base is pinched out of the clay and shaped, while the remainder of the pot is formed by coiling.

The pot is dried and this takes a week, a month, or more depending on the size of the pot, environmental conditions and how busy the potter is with other duties. Pottery making is not a nine to five activity, but is undertaken between household, business, farming and religious duties. At this stage the pot is like a piece of leather and can be handled easily. If the pot was smoothed before it was dried it will require less sanding at this point, although it generally takes about one hour for an average sized piece. Today sandpaper is used but in the past it was pumice.

The Nahohais, as well as other potters, get their slip from the Acoma/Laguna area. Slip is a fine white clay or kaolin which is mixed with water and "brushed" over the surface of the pot as a base or background for the painted designs. The kaolin from this area needs very little cleaning, but if it does it is washed and screened in the same way as the clay for the body of the pot. Today the slip is applied with sponges which will not leave marks on the surface, but in the old days a piece of rabbit skin was used. The slip dries rapidly, but while it is still damp, the surface is polished with stones for about an hour. River washed stones are often used but sometimes commercially tumbled agates are employed.

Painting to many people is the most artistically important part of pot making and the most difficult process to plan for in terms of time (and to discuss!). A small piece may take a half day and a larger one two days to a week. Milford says: "If I see the design, [in his mind's eye] then it won't take very long. If I don't see it, then it will take a long time." The pigments are yellow limonite or ochre which fires red and boiled parts of the beeweed formed into a little cake and mixed with hematite or ground iron ore for the black. (Fig. 24)

Sometimes prior to the final step of firing the pots, they are prefired or warmed in the household oven just until the yellow paint starts to turn red. The Nahohais build a traditional Pueblo kiln behind their house, and the ground, like the sheep manure used for fuel, must be dry with no wind to whip the fire out of control or cause smudges on the surface. The pieces to be fired (the pots of several members of the household are often fired together) are placed over a base of blocks and wood chips with a few sacred offerings for the success of the firing. Over this stack is placed manure and the sheet metal covering of the kiln. They leave an empty space of about one and a half feet above the stacked pots, as Josephine says "for the fire to dance around in". The firing lasts for about one hour, but is the most dangerous part of the entire process, as all the previous days and even months of

work can be ruined in this one hour. After the manure has burned to ashes, the pots are removed with sticks and placed in a pan and taken inside the house to cool. Sometimes the ash that is left over is used as the base of the construction of a new bread oven. The ash helps the new oven to retain its heat better. The final step after the pottery has cooled is "then go look for a buyer" says Milford.

The Kalestewa Family

The Kalestewas essentially work in the same ways as the Nahohais and other potters, but do differ in some respects. Only Quanita and Jack gather the clay for the family, leaving their children and grandchildren at home. They go to the Nutria area and gather about a tub full of clay at one time (larger than a wash tub but less than a five gallon bucket). The major difference in preparing the clay is that the Kalestewas grind up the impurities rather than screening them out. They use the base of an old pot for the base of the new rather than shaping the base as the Nahohais do. About halfway up the pot they begin shaping it from the inside rather than the outside. Quanita prefers to use her hands to apply the slip rather than a sponge.

Firing is done at their sheep camp outside the village, close to the source of the manure. The kiln area is about four feet square and is in the same area each time. It holds about ten medium sized pots at one time with rebar after they are stacked. Again this is the most critical time in the genesis of a Zuni pot.

☙☙☙☙☙☙☙☙☙☙☙

Reading List

Bunzel, Ruth
 1929. *The Pueblo Potter: A Study of Creative Imagination in Primitive Art*. Columbia University Contributions to Anthropology, 8. New York. (Reprinted: Dover, New York, 1972.)

Cushing, Frank Hamilton
 1886 "A Study of Pueblo Pottery as Illustrative of Zuni Culture Growth". *Fourth Annual Report of the Bureau of American Ethnology for the Years 1882-1883:* 467-521. Washington, D.C.

Ferguson, T.J. and E. Richard Hart
 1985. *A Zuni Atlas*. Norman: University of Oklahoma Press.

Hardin, Margaret Ann
 1983. *Gifts of Mother Earth: Ceramics in the Zuni Tradition*. Phoenix, Arizona. The Heard Museum.

Ladd, Edmund J.
 1979. "Zuni Social and Political Organization." *Handbook of the North American Indians*. Vol. 9:482-491. Washington, D.C.

Mera, Harry P.
 1937. *The Rainbird: A Study in Pueblo Design*. Laboratory of Anthropology. Memoir 2. Santa Fe. (Reprinted: Dover, New York, 1970.)

Stevenson, Matilda Coxe
 1904. "The Zuni Indians: Their Mythology, Esoteric Fraternities, and Ceremonies". *23rd Annual Report of the Bureau of American Ethnology for the Years 1901-1902.* 1-634. Washington, D.C.

Woodbury, Richard B.
1979. "Zuni Prehistory and History to 1850." *Handbook of North American Indians.* Vol. 9:467-4473. Washington, D.C.

Zuni History Project
1983. *Zuni History.* Sun Valley, Idaho. Institute of the American West.